W9-CTJ-250

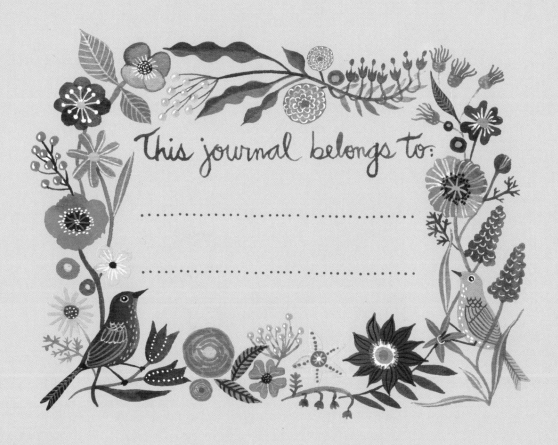

This journal belongs to:

..

..

Color Me

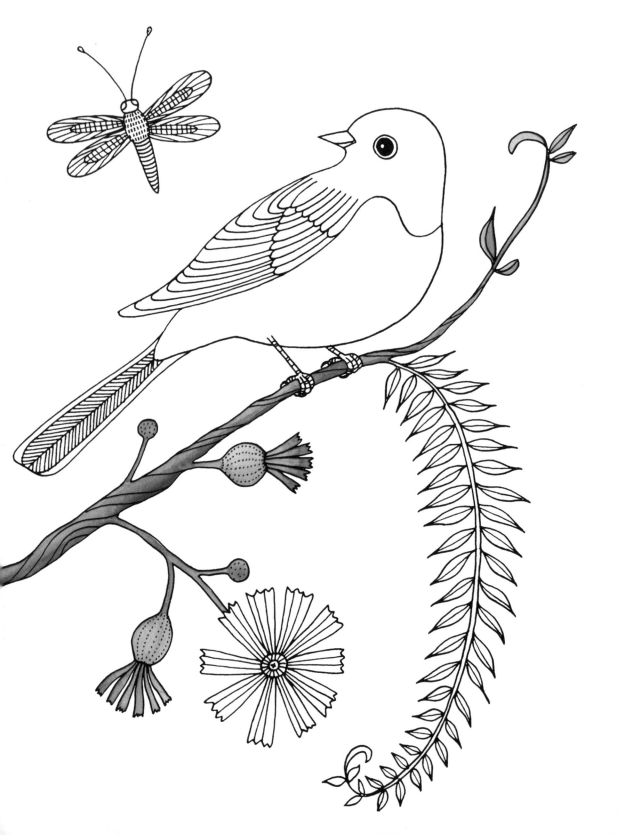

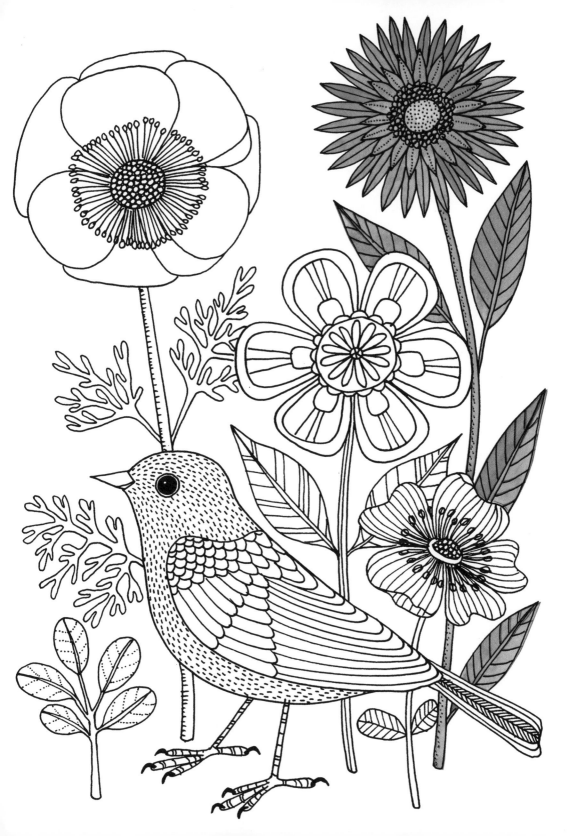

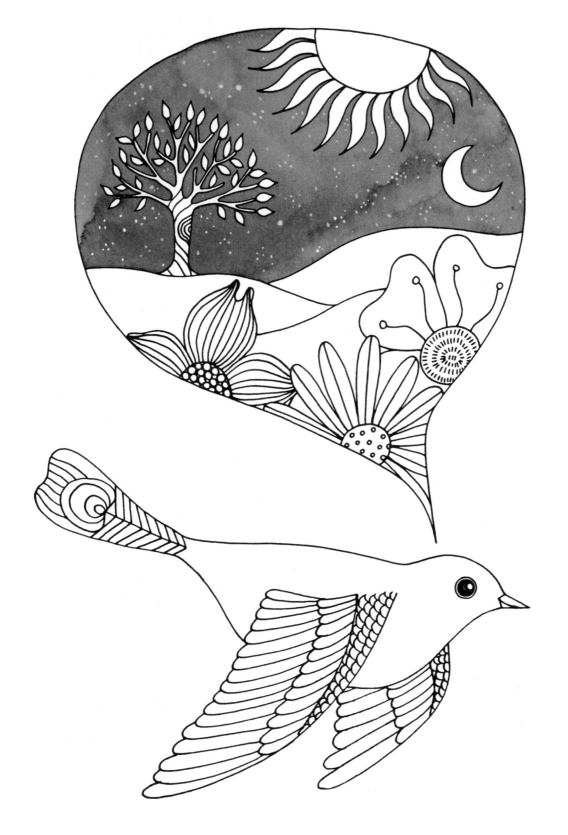

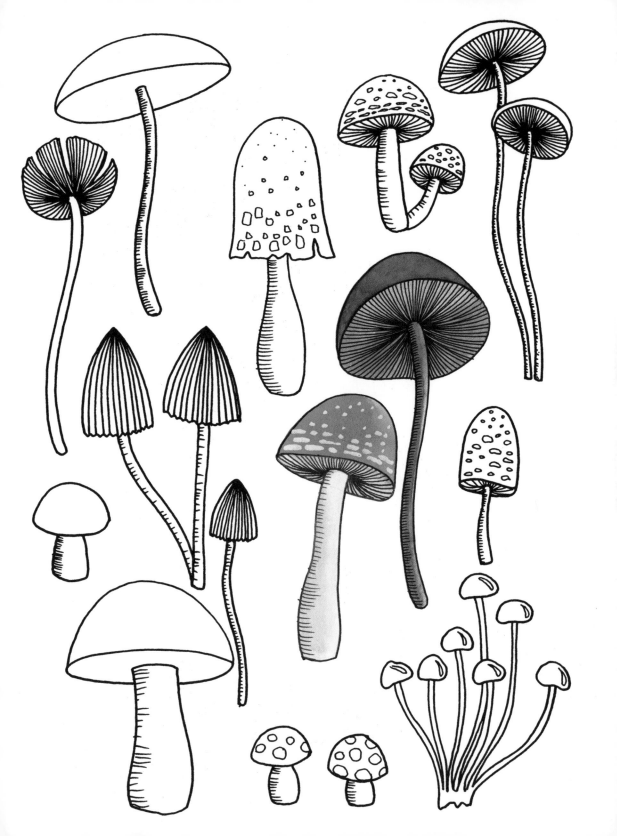

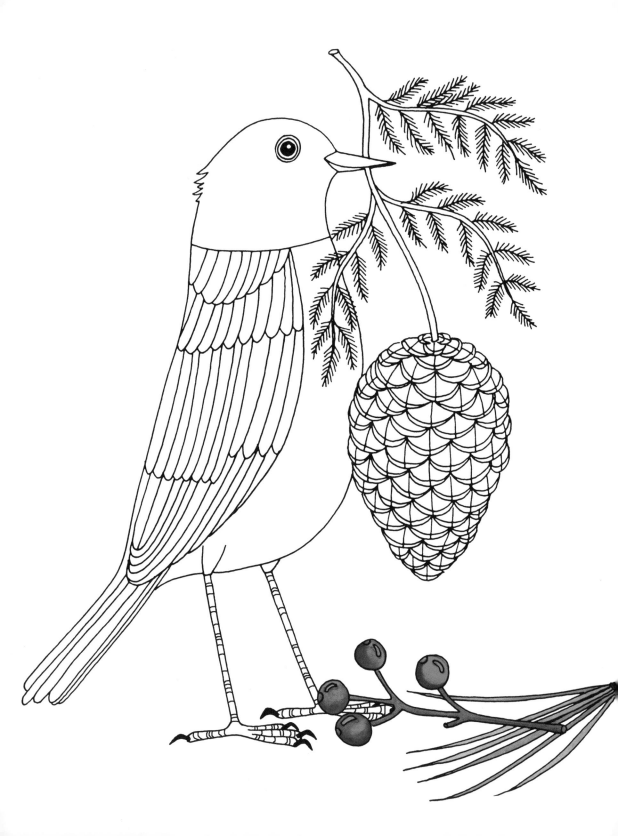

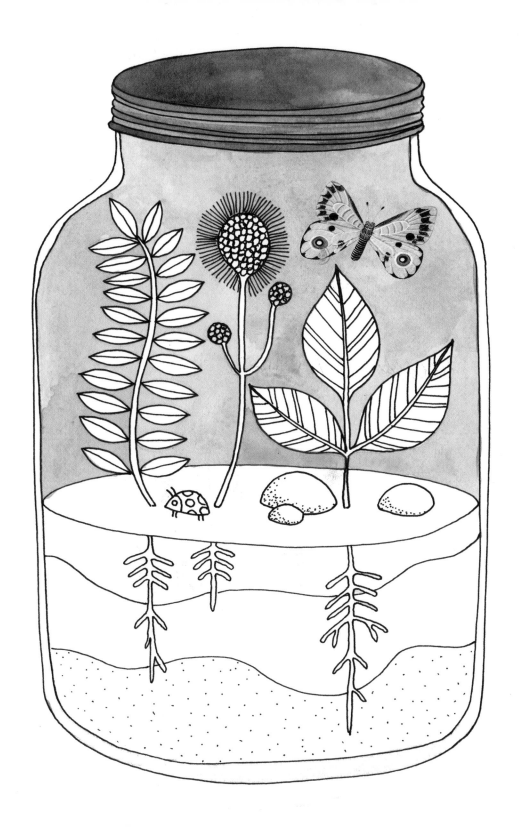

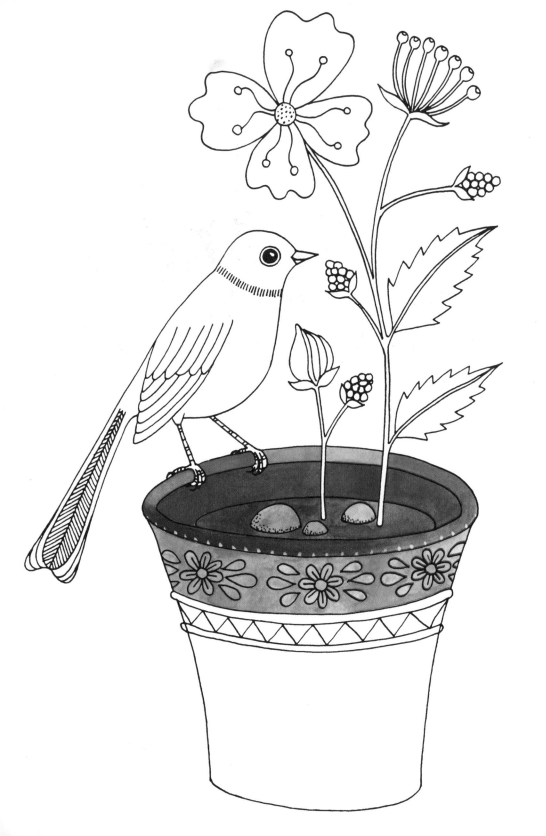

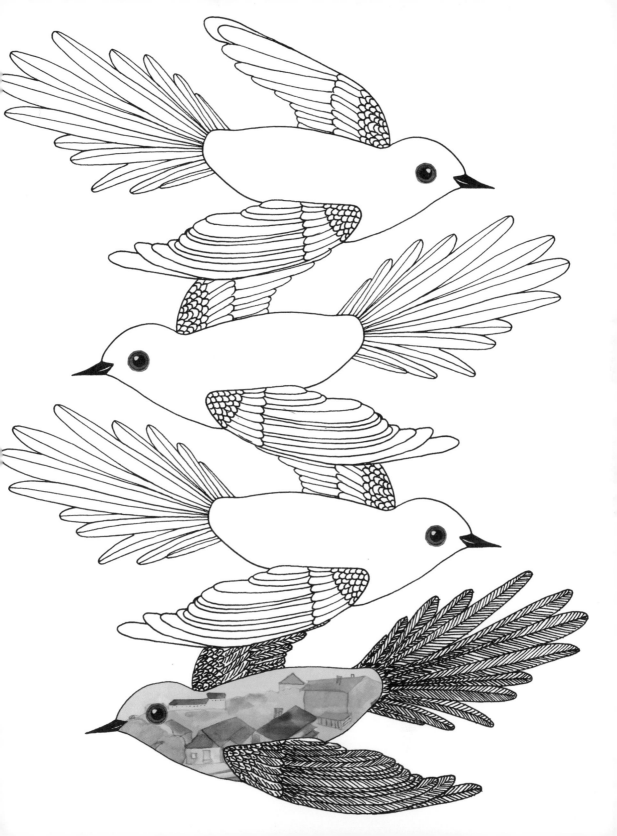

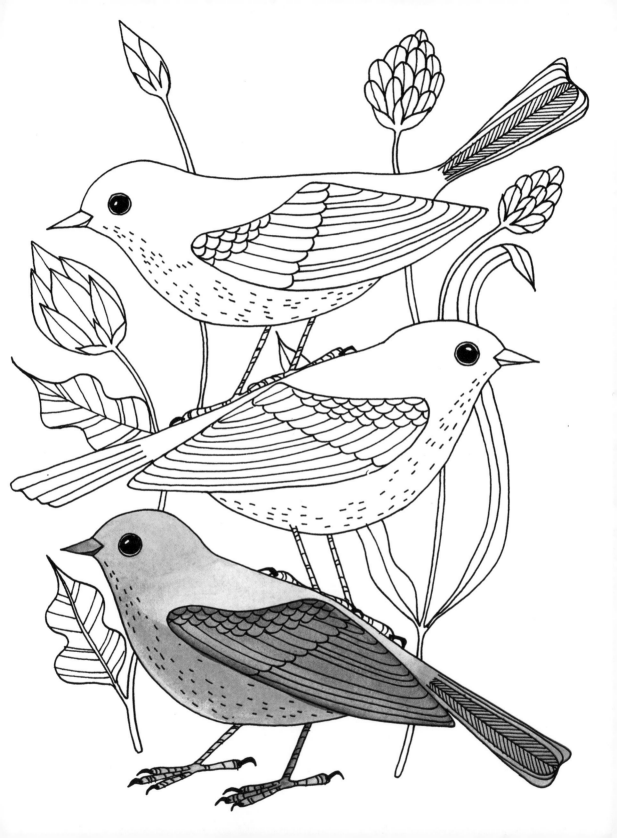

Watercolor Paintings

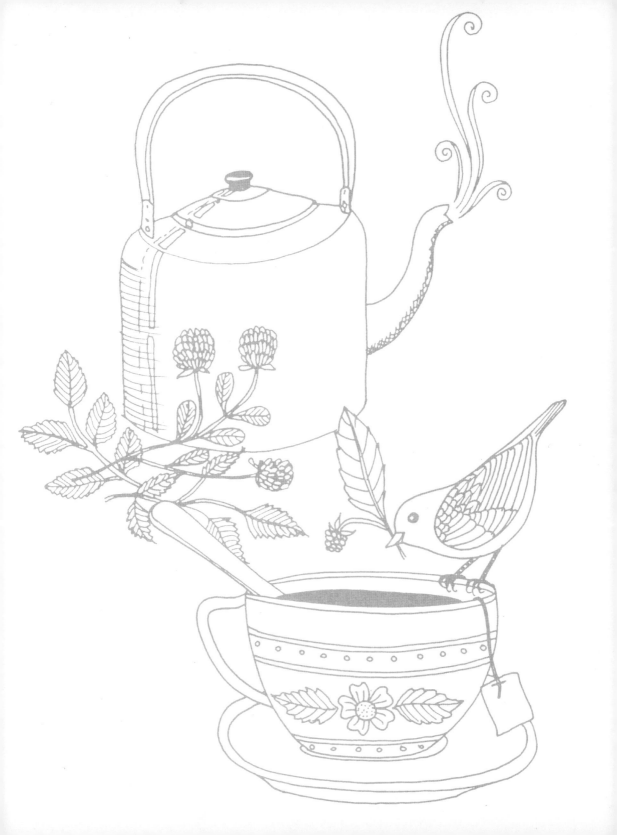

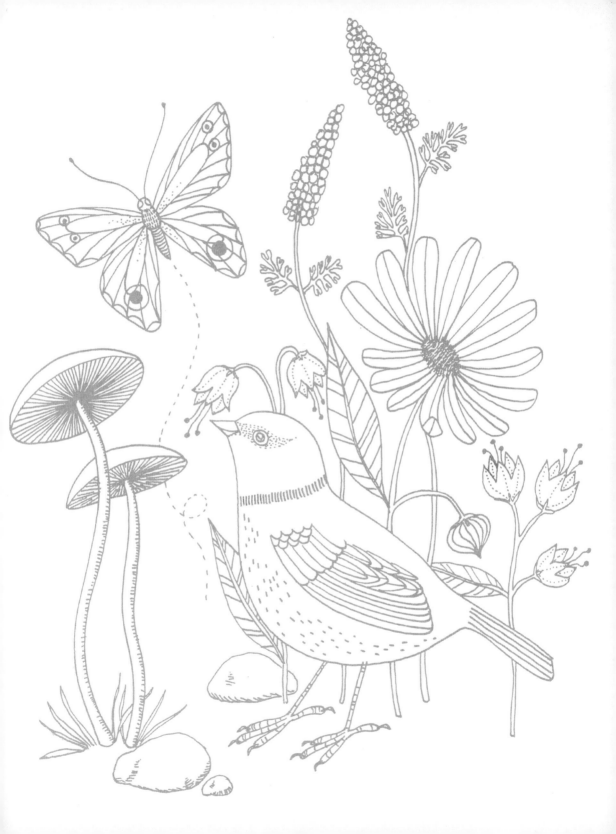

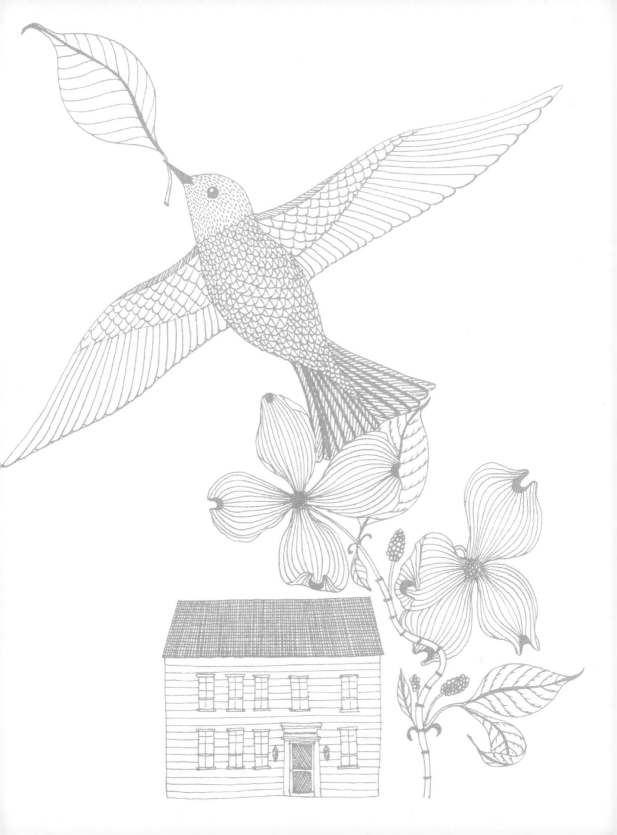

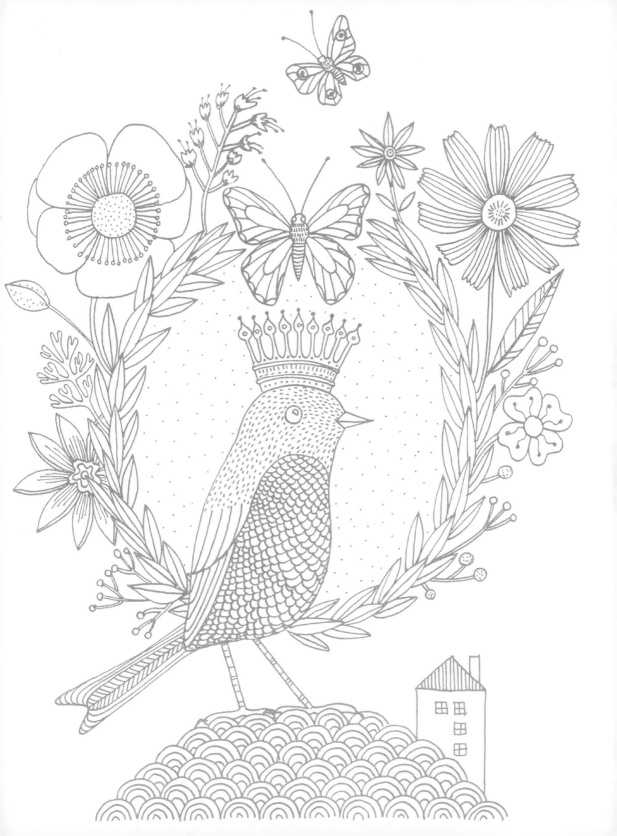

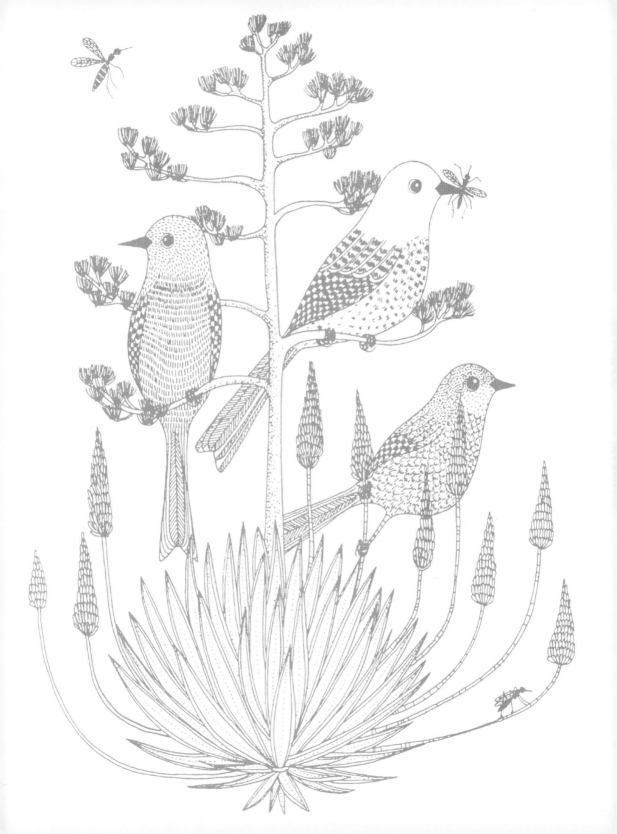

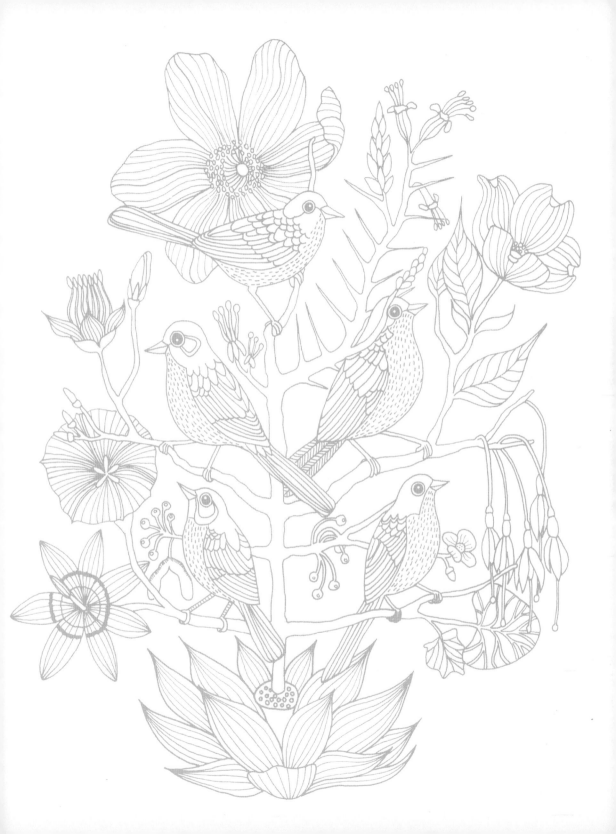

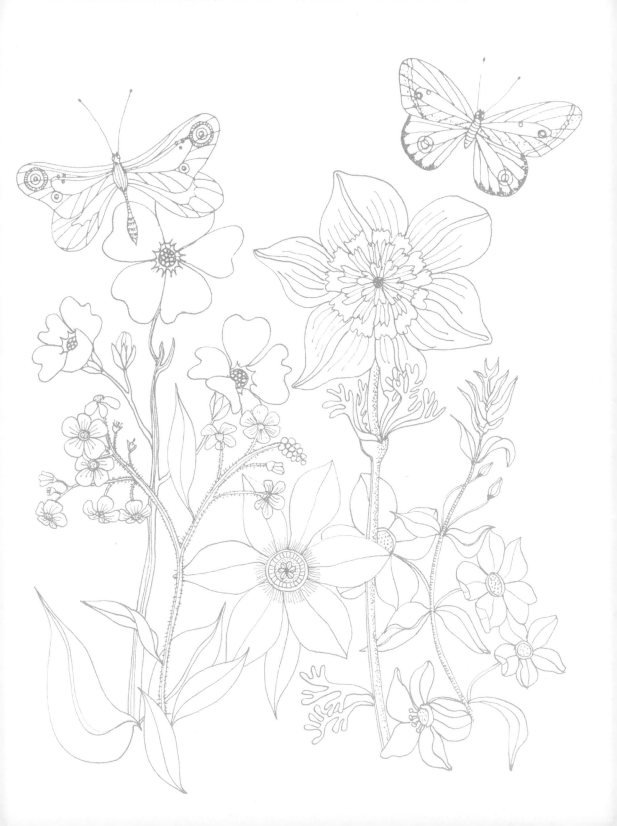

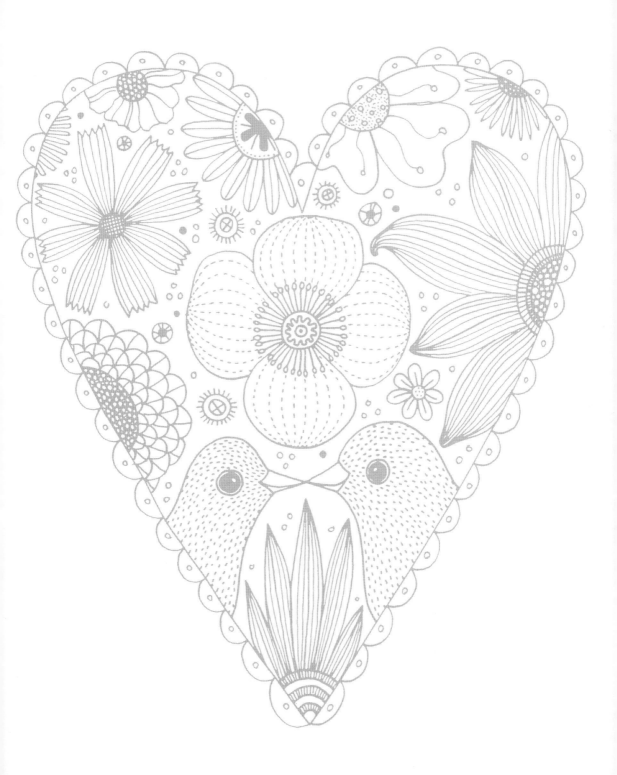

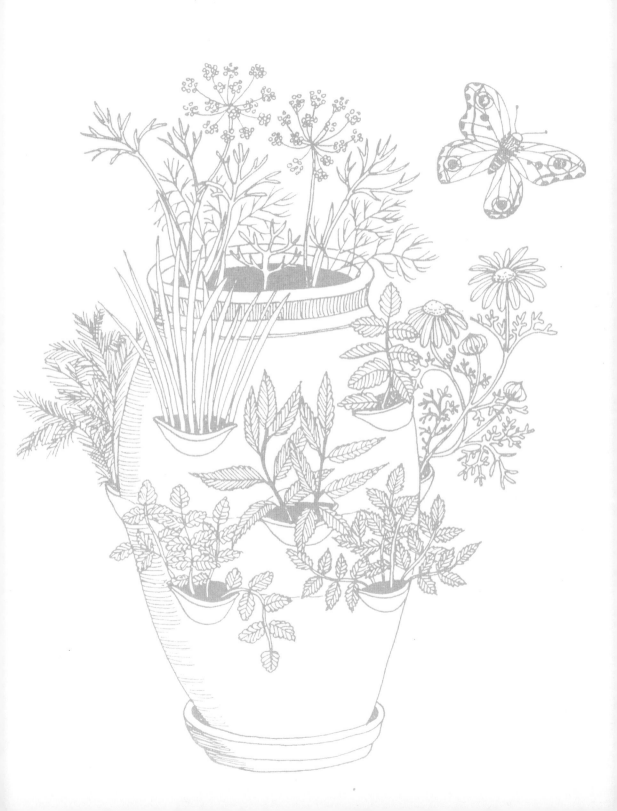

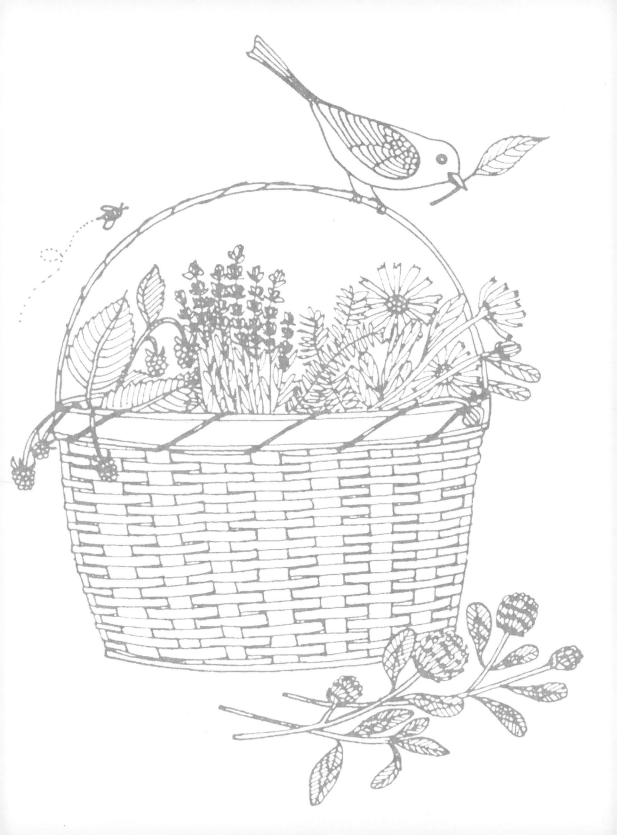

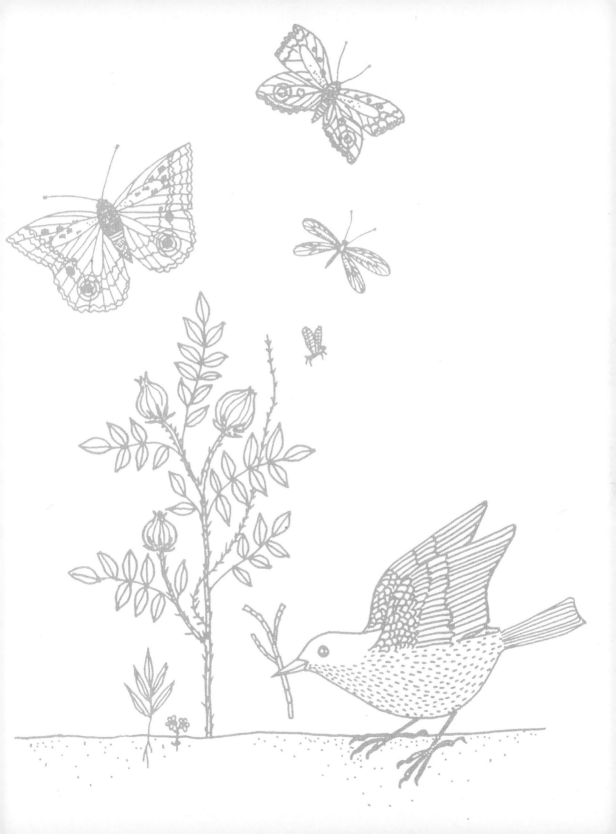

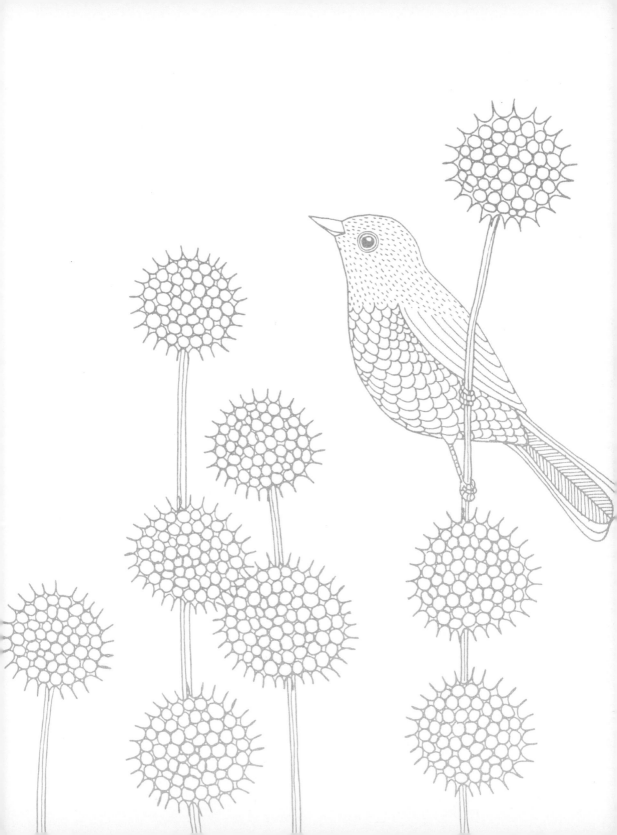

Activities

Take part in this feathered discussion!

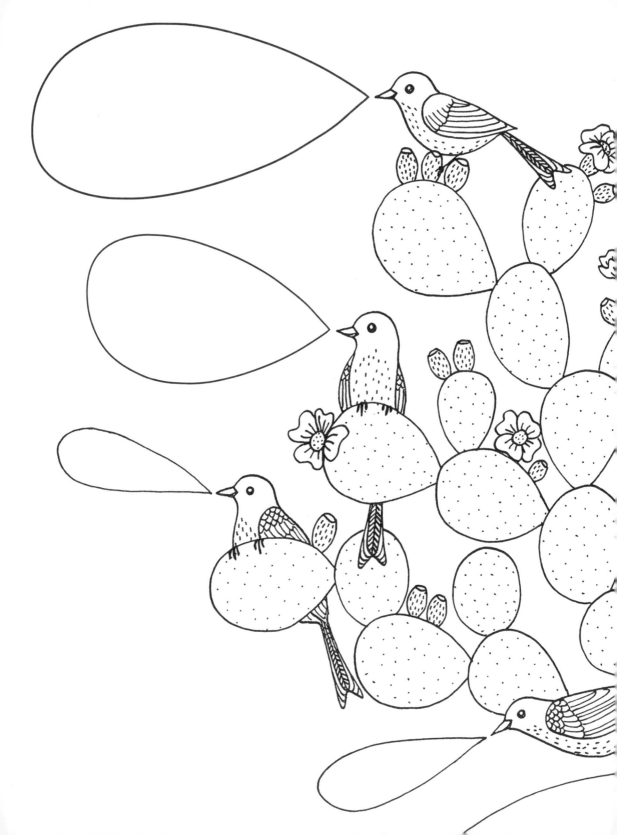

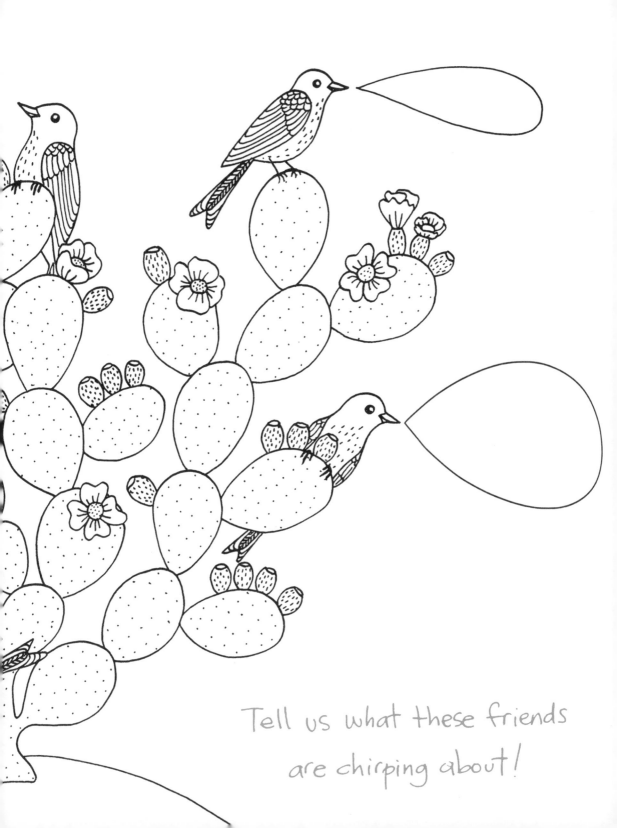

Tell us what these friends are chirping about!

Build some dream homes for the birds!

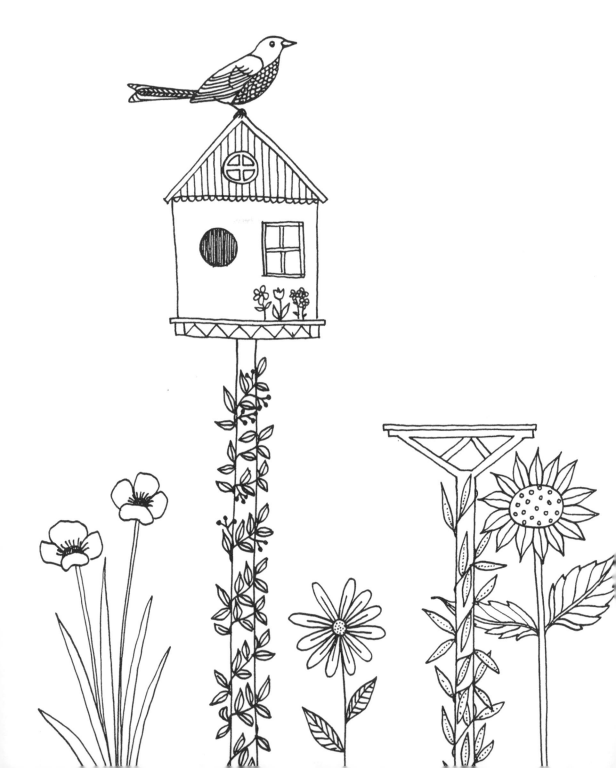

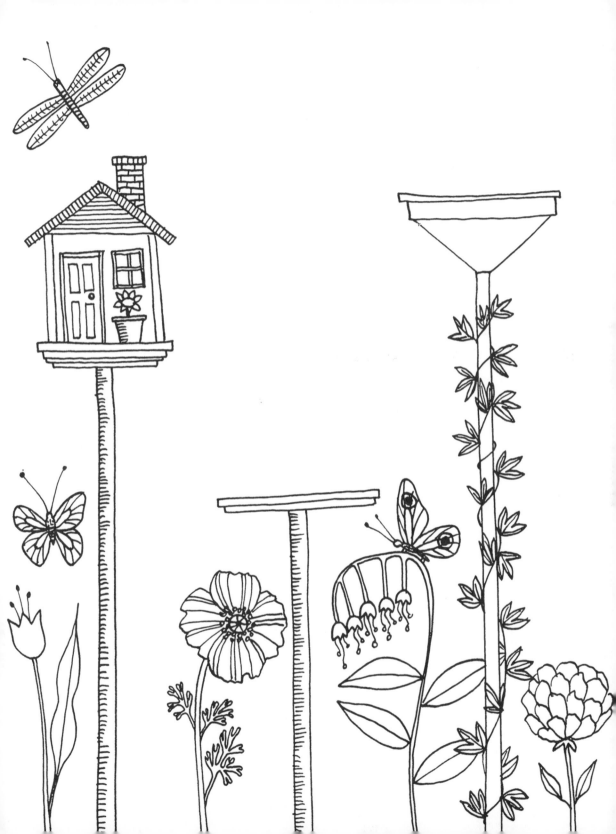

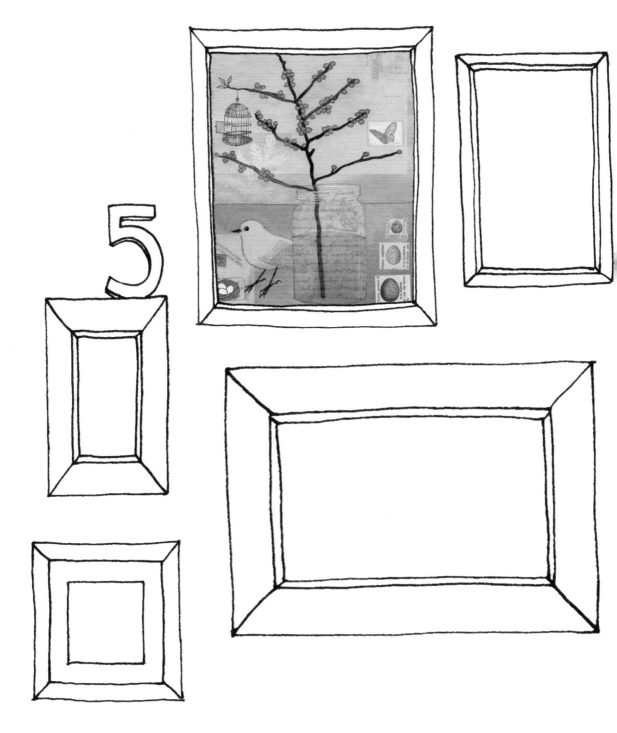

Draw in some colorful masterpieces of your own.

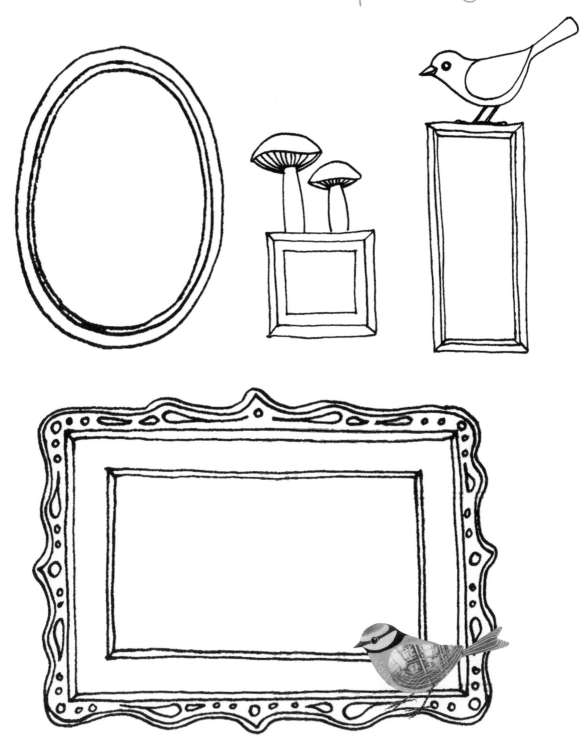

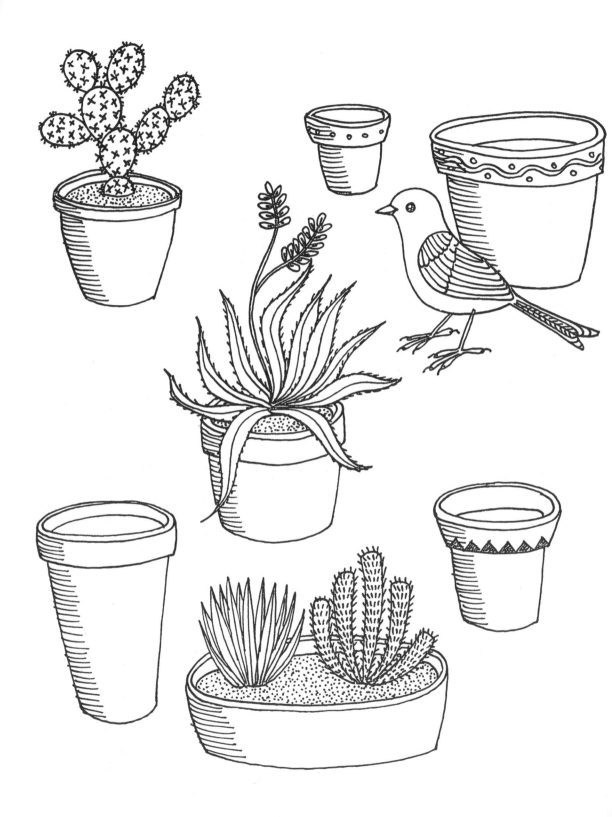

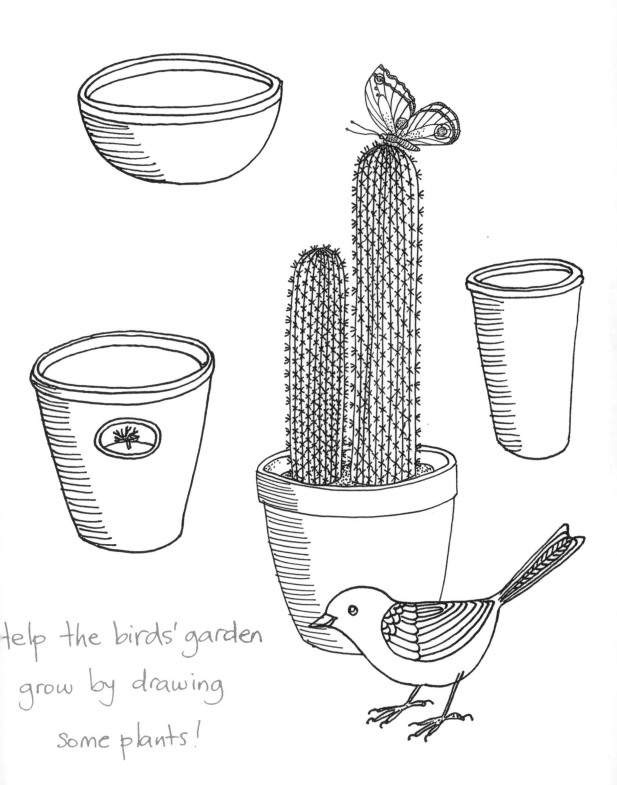

help the birds' garden grow by drawing some plants!

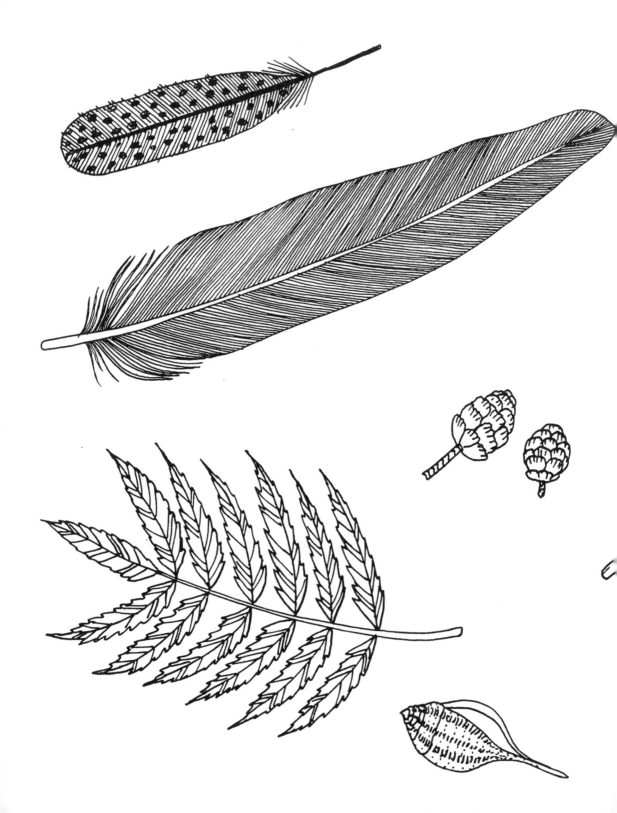

Draw some other little treasures of nature.

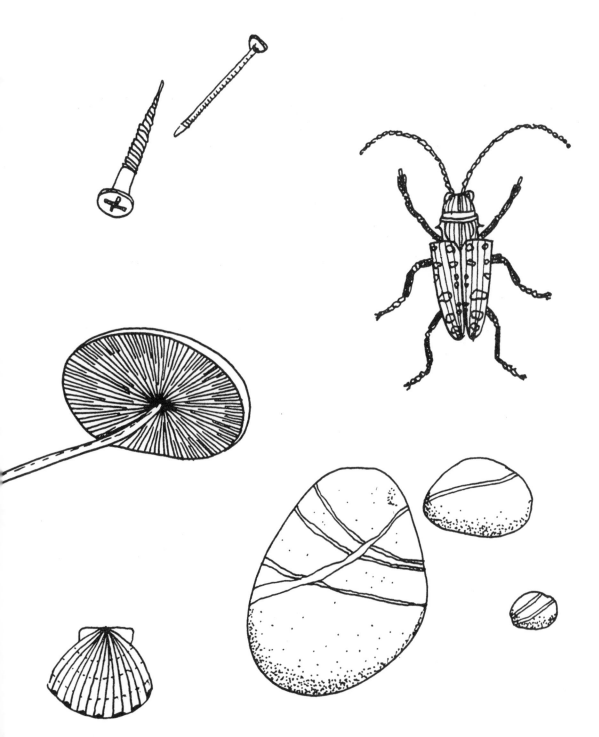

Plant some of your own art
into these foliage frames.

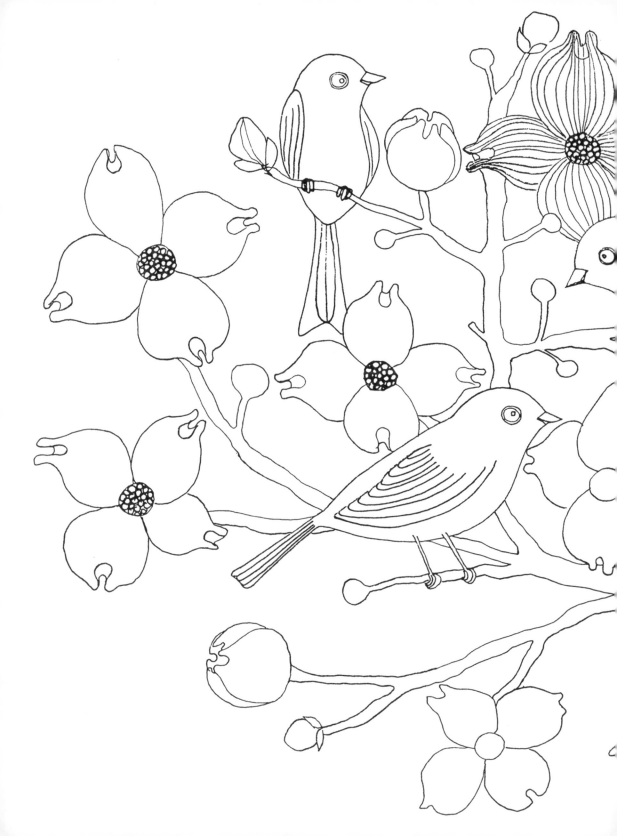

What other birds have stopped to smell the flowers?

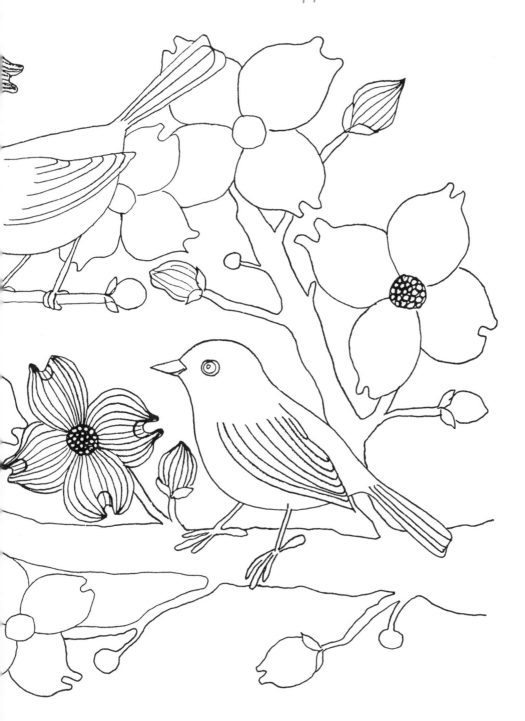

Draw the other gorgeous butterflies that have joined this garden party.

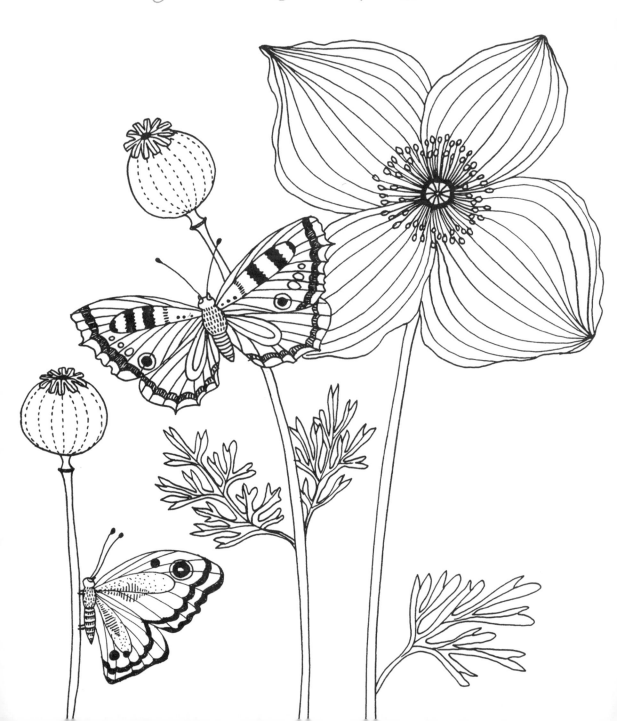

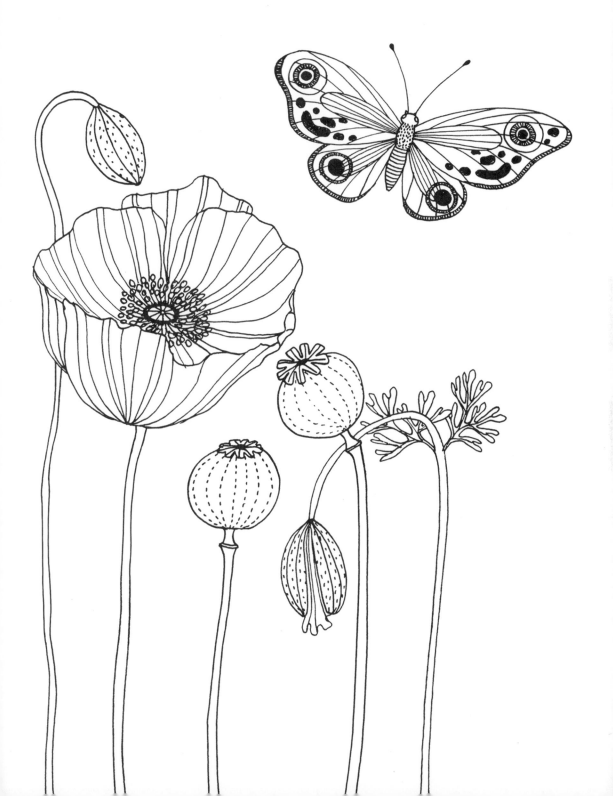

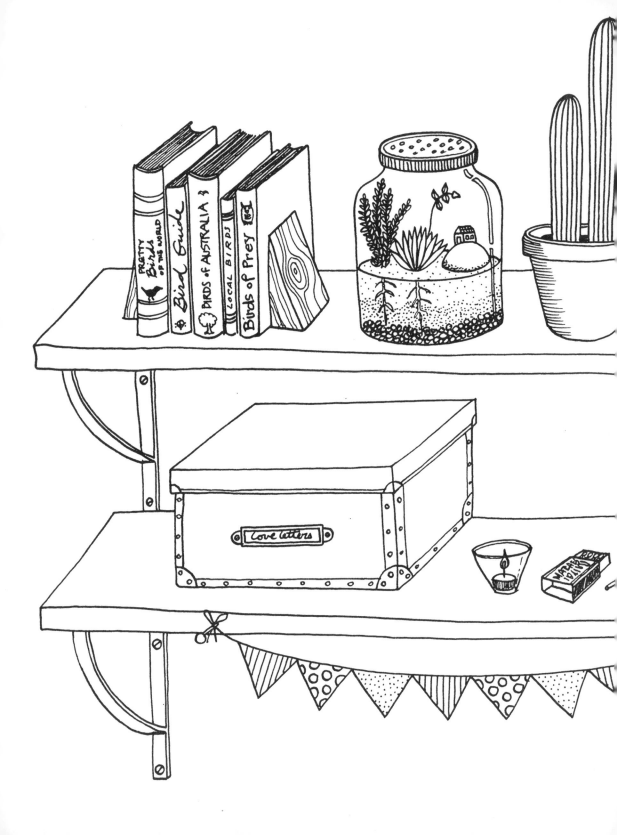

What other treasures do you have on display?

Sketch
and Journal

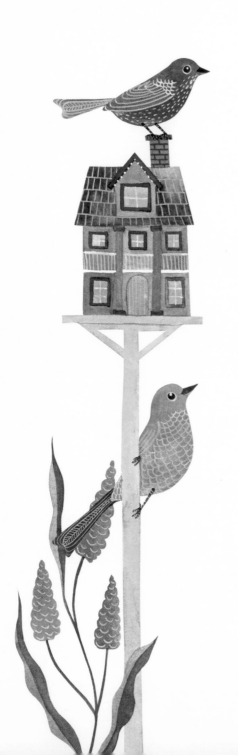

Just as the bird sings or the butterfly soars, because it is his natural characteristic, so the artist works. ALMA GLUCK

How can I be in two places at once, unless I were a bird?
BOYLE ROCHE

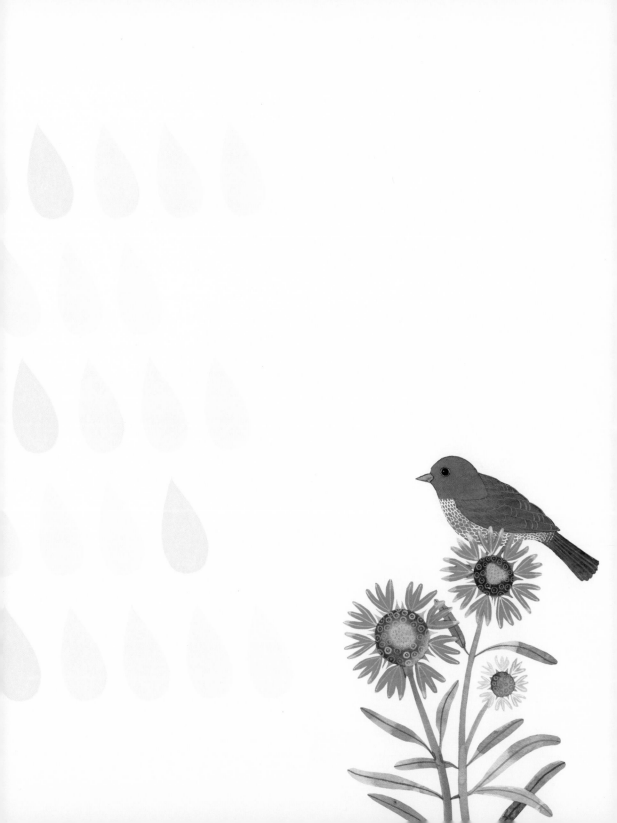

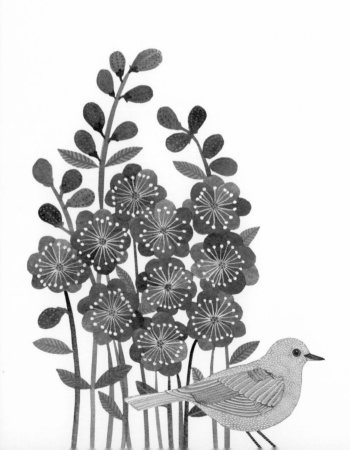

Faith is the bird that feels the light when the dawn is still dark.
RABINDRANATH TAGORE

A bird doesn't sing because it has an answer, it sings because it has a song. MAYA ANGELOU

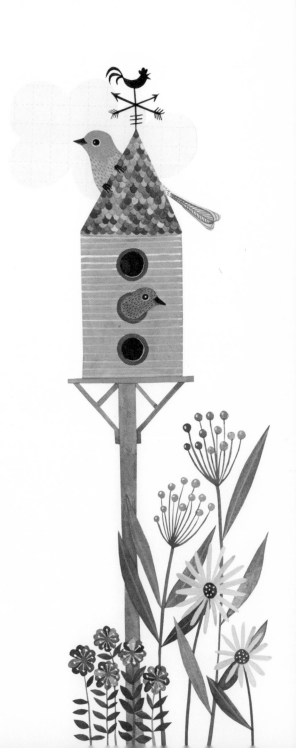

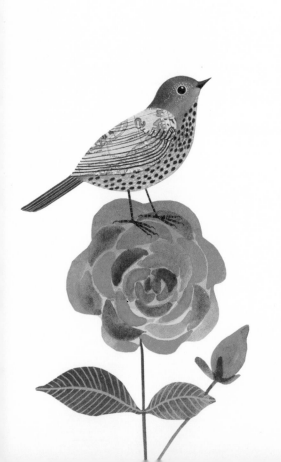

No bird soars too high if he soars with his own wings.
WILLIAM BLAKE

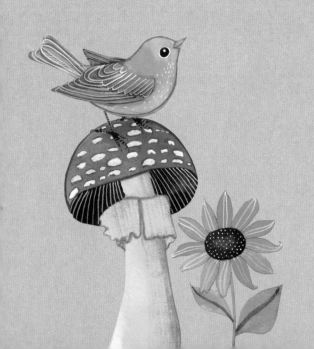

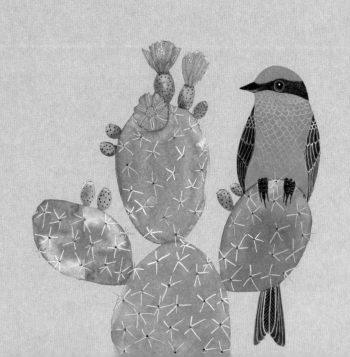

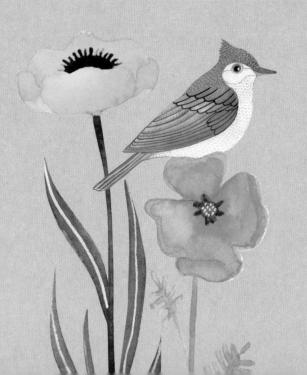

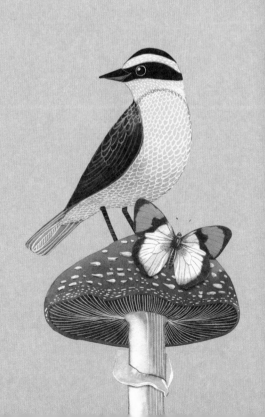

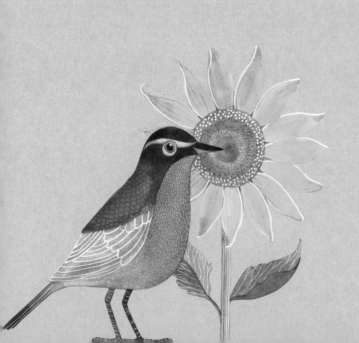

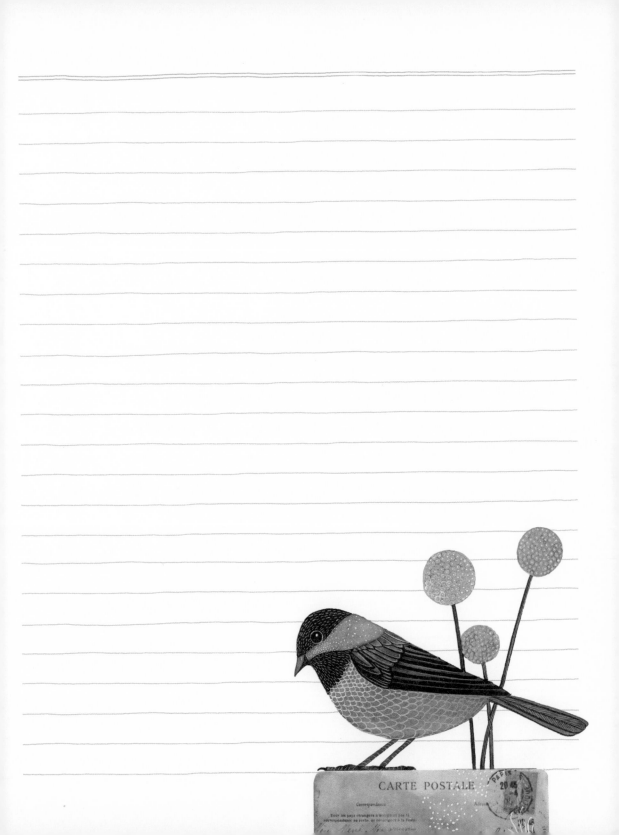

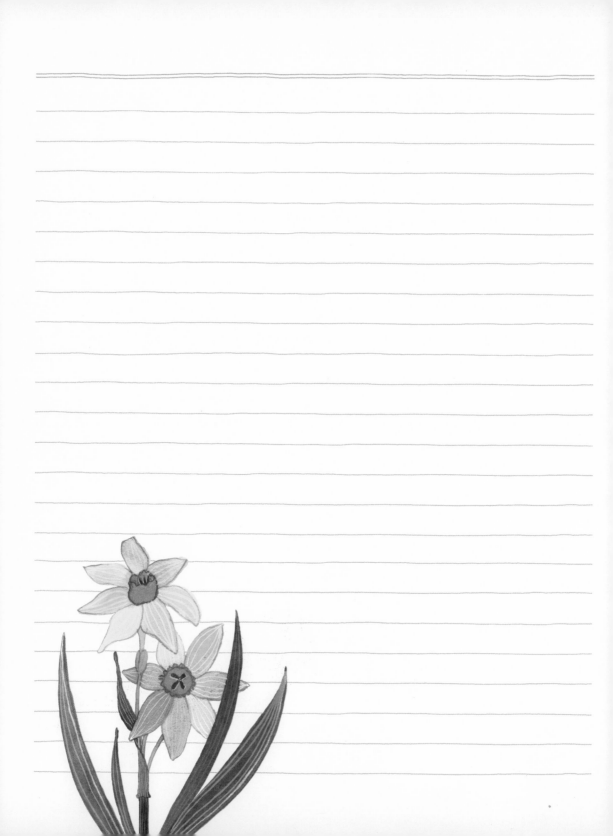

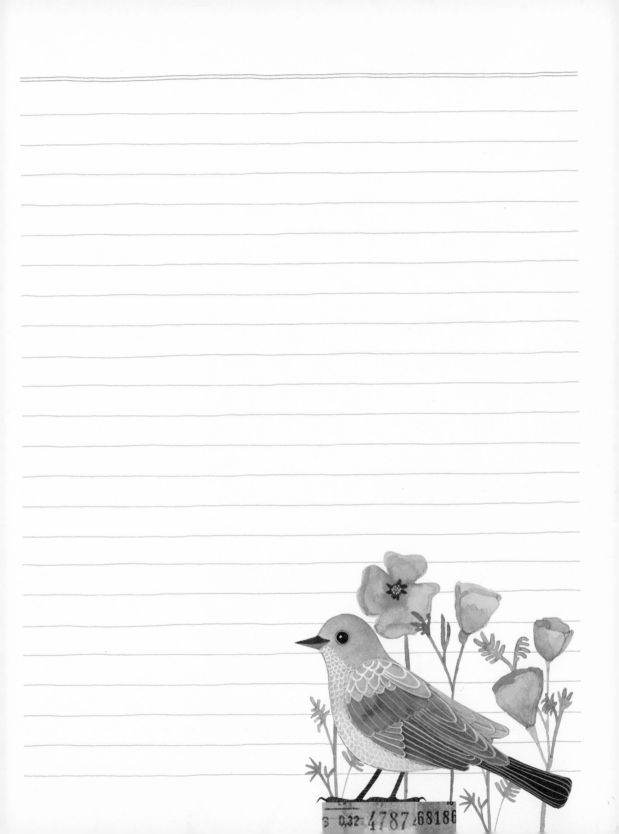

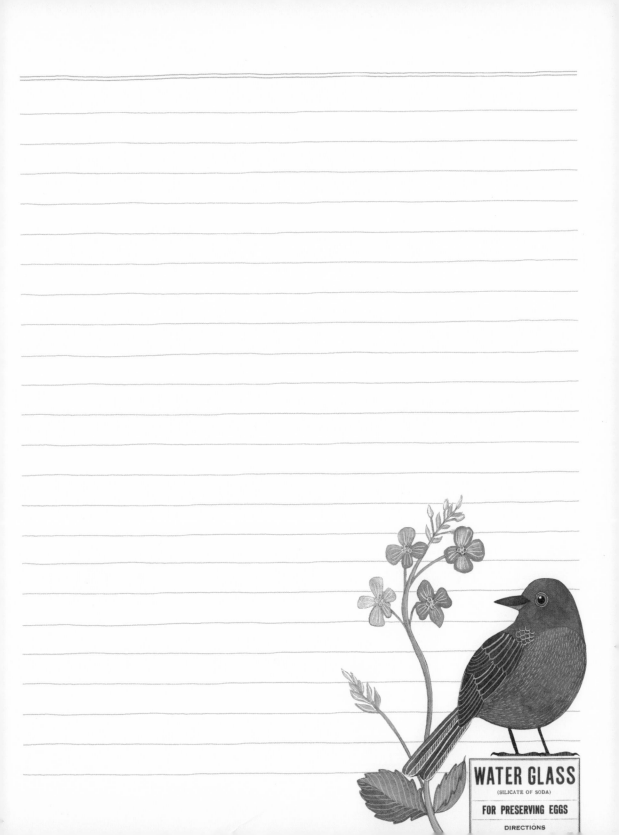

WATER GLASS
(SILICATE OF SODA)

FOR PRESERVING EGGS

DIRECTIONS

Meet the artist: Geninne Zlatkis

Geninne Zlatkis is a multi-talented illustrator who embraces various mediums (painting, collage, writing, stamping, and more) in her whimsical and nature-inspired work. Born in New York, she now lives in Mexico with her husband, two sons, and a cute Border Collie named Turbo. Geninne's blog can be found by visiting www.geninne.com.

Where do you find inspiration?

I've always been drawn to flowers and critters. I find that nature is an infinite source of inspiration if you stop and look closely. Nothing inspires me more than to have a nice long walk at a park or nature reserve with my camera in hand. I also love looking at antique science, botany, and natural history books.

Birds are frequently featured in your work. Do you have a pet bird?

I just couldn't bear to have a bird in a cage. They are meant to be free and that is what I admire most about them. With all the beautiful trees that surround our home, I have all the birdies I need. They are all my pets!

What kinds of wild birds visit your garden in Mexico?

My favorite visitor is the Vermilion Flycatcher. He's drop-dead gorgeous and has a wonderful personality. We have spotted woodpeckers, many different warblers, sparrows, blue mockingbirds, Mexican jays and beautiful hummingbirds.

How does your environment shape your paintings?

Living in Mexico has most definitely influenced my art: It is a very lush, colorful and diverse country. We've moved around quite a lot; while we lived in the semi-desert I painted more cacti and succulents, and now that I live in the forest I tend to paint woodland scenes.

What is your painting process?

I usually just draw directly on my watercolor paper with a light pencil line. I use a medium-sized watercolor brush to color in my areas and wait for them to dry before applying another color. You have to be very patient! I'll paint an area in one color, and then paint another area that is not adjacent to the one that is still wet—sort of like painting by numbers.

How do you choose a color palette?

Sometimes I'll see a wild color combination on a flower or a butterfly that I want to replicate, or on a fruit pile at the market. I'm always on the lookout for beautiful color combinations, and love creating contrasts between warm and cool colors.

What is your recommended supply list?

Splurge on a good quality watercolor set; I love the ones with half pans in lots of different colors. You will also need to buy a few brushes in different sizes: a very fine liner brush for details, a medium-sized round brush, and a larger one for filling in larger areas. I use mostly synthetic brushes, but the natural bristle ones are great and worth the investment. Have a pencil and a nice soft eraser on hand for drawing, a good quality watercolor paper block or pad (I like to use 100% cotton paper), and a small jar with clean water.

What advice would you give someone new to the watercolor technique?

Have fun with it! Experiment, and don't try to replicate a preconceived notion of what watercolors are supposed to look like. I never took a watercolor class and I think that was the key to developing my own technique.

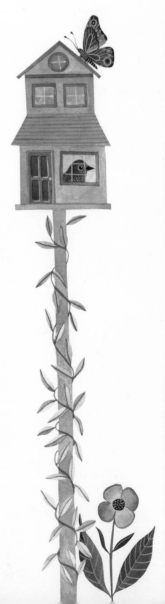

What other media do you like?

I enjoy all media! I love to embroider, which is just like painting with thread. I discovered hand-carving stamps a couple of years ago, and I'm completely hooked. I use a variety of mediums—like oil paints, inks, markers, colored pencils, etc.—but my first love will always be watercolors.

What artists have influenced your work?

I am hopelessly in love with the work of Van Gogh and Georgia O'Keeffe. They were both bold and brave in their art, and it really speaks to me. A contemporary artist I really love is Olaf Hajek; we share a love of flowers, birds and lots of color.

How has your style developed over the years?

Time has been an essential factor. As the years have gone by I've become more patient and better at observing. My style has become more detailed, precise and reflective of me. Style is something that develops naturally when you really love what you do.

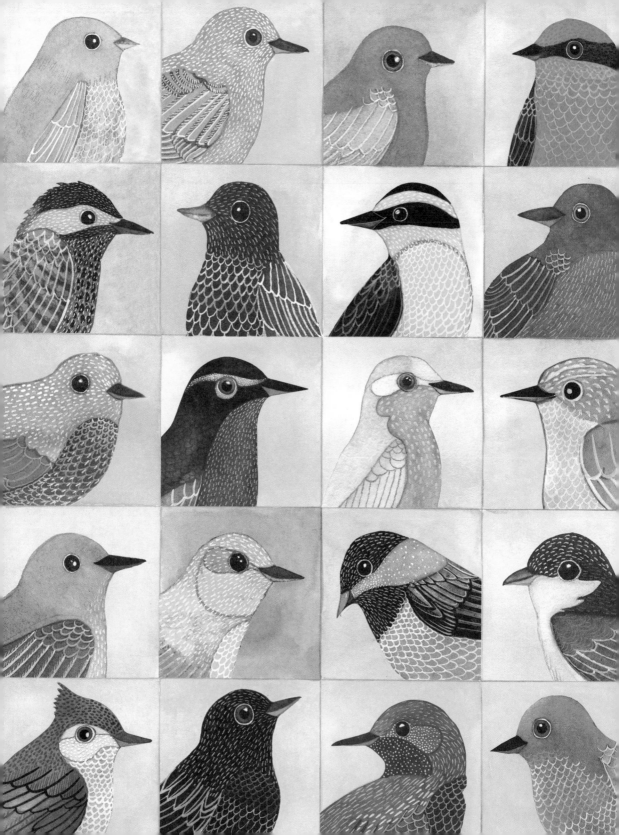